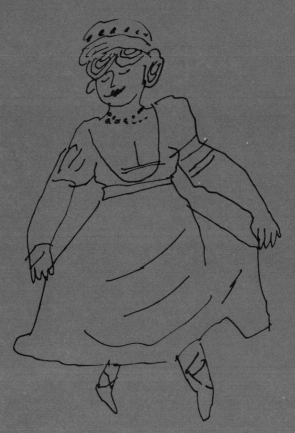

STYLE, STYLE, STYLE

merry Christmas Anne
you help us
with this in a very
unique wonderful way.
Santa 1998

STYLE, STYLE, STYLE

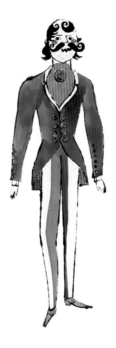

ANDY WARHOL

A BULFINCH PRESS BOOK

LITTLE, BROWN AND COMPANY BOSTON NEW YORK TORONTO LONDON

FIRST EDITION
Quotations from Andy Warhol compiled by R. Seth Bright
Designed by John Kane

Library of Congress Cataloging-in-Publication Data

Warhol, Andy
 Style, style, style / Andy Warhol. — 1st ed.
 p. cm.
 ISBN 0-8212-2320-8 (hc)
 1. Warhol, Andy — Themes, motives. 2. Clothing and dress in art.
I. Title.
NC139.W37A4 1996b
741.6'72'092 — dc20 96-14264

Bulfinch Press is an imprint and trademark of
Little, Brown and Company (Inc.)
Published simultaneously in Canada by
Little, Brown & Company (Canada) Limited

PRINTED IN SINGAPORE

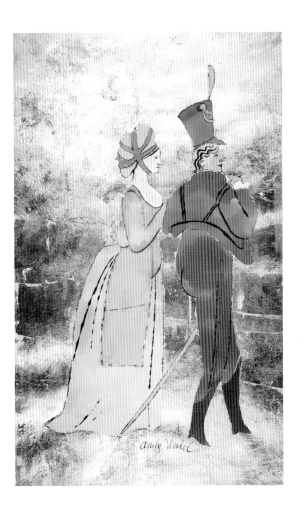

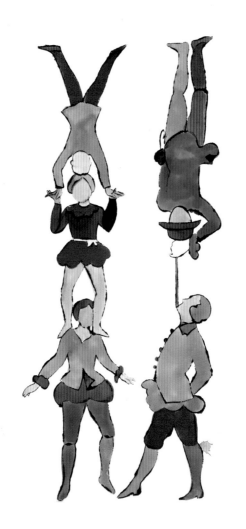

It takes a lot
of work
to figure out
how to look
so good.

Fashion

wasn't what
you wore
someplace
anymore;

it was the whole reason
for going.

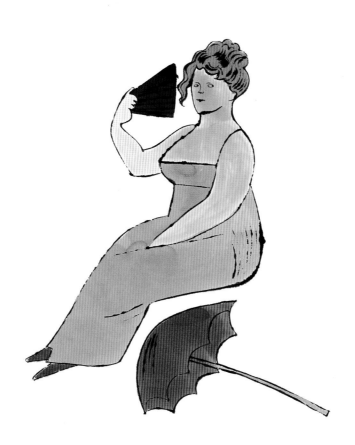

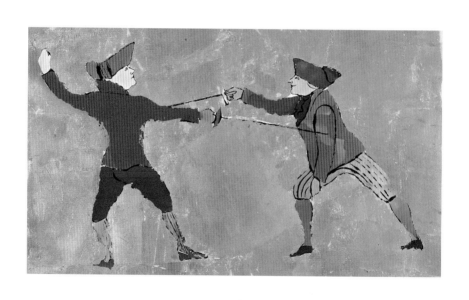

In those days everything was extravagant.

No, they haven't worn hats in a long time.

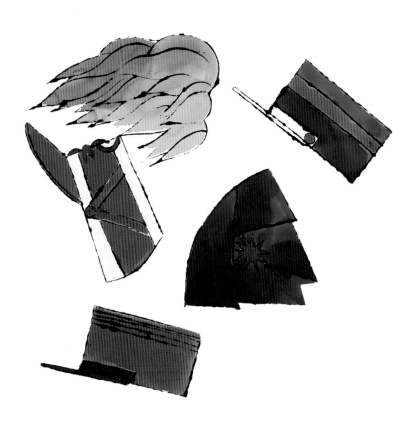

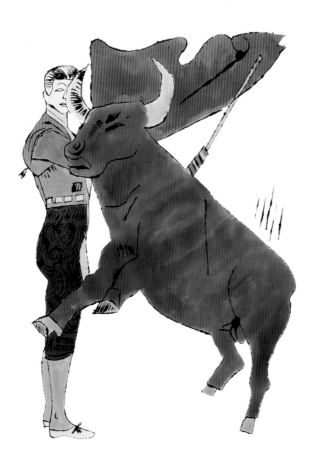

If there's nothing there,

clothes

are certainly not
going
to make
the man.

He was just simple black and white elegant

and there was a very sad look to him somehow.

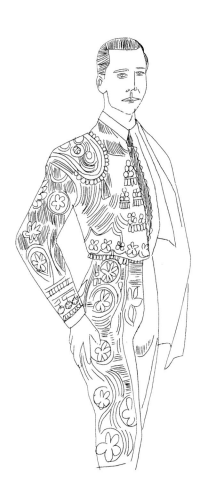

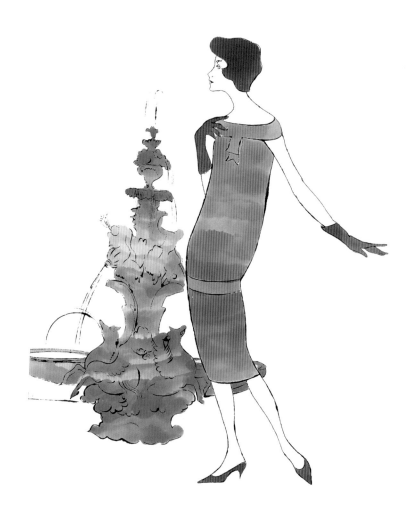

You **never** knew in advance
if she'd look like

a million
or like **two cents**.

And the way she'd decide

she should look would have

nothing to do with where you were going.

Looking at store windows
is great entertainment
because

you can see
all these things

and be really glad
it's not home
filling up
your closets
and drawers.

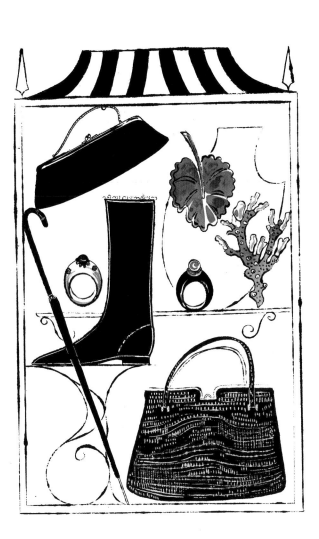

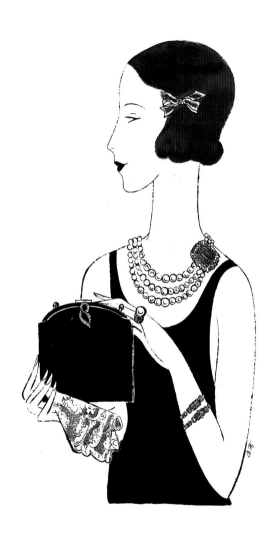

She always had

the most expensive

makeup

and

the newest

clothes.

Remember,

they've **never** seen you before
in their life.

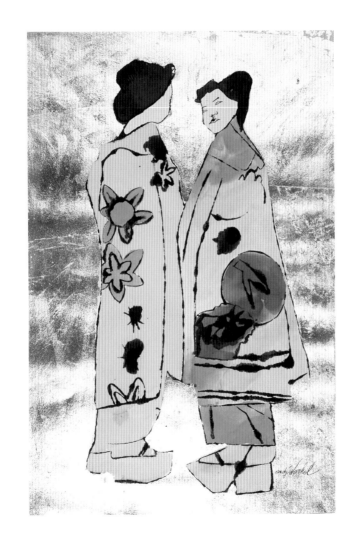

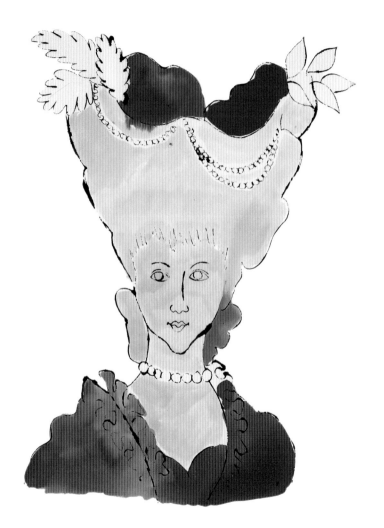

And now what people want is only

one

of a kind.

Most of us need a little preparation to get into the mood we need.

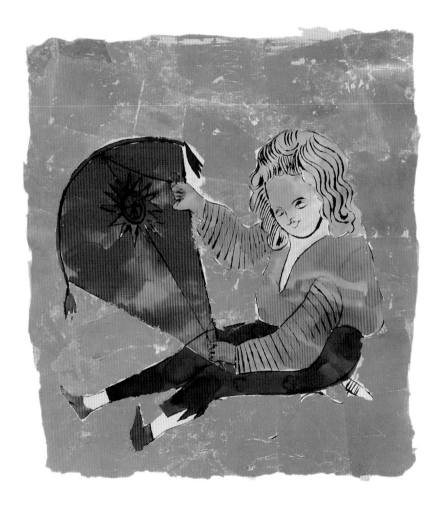

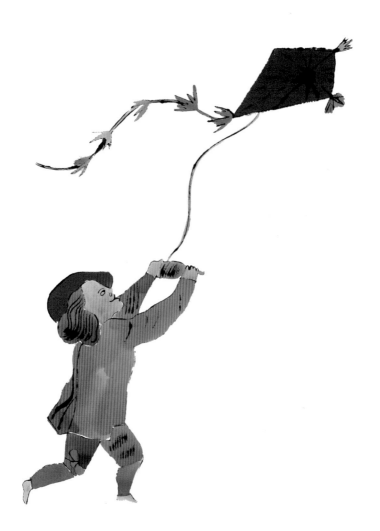

You just need
the right **attitude,**
the right **clothes,**

and being **clean.**

They *should* have

good-looking
people

walking around in their clothes

for
free.

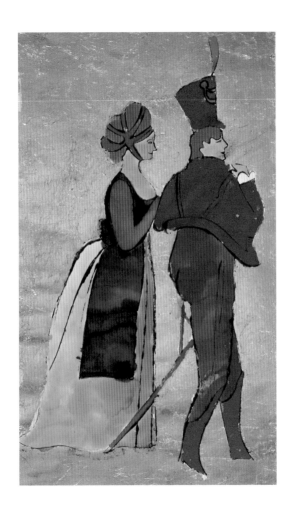

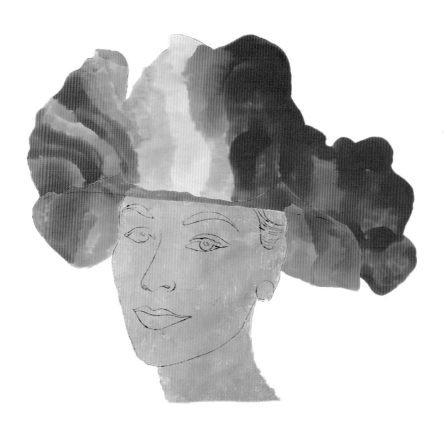

Everybody must have a fantasy.

Fantasy and clothes

go together
a lot.

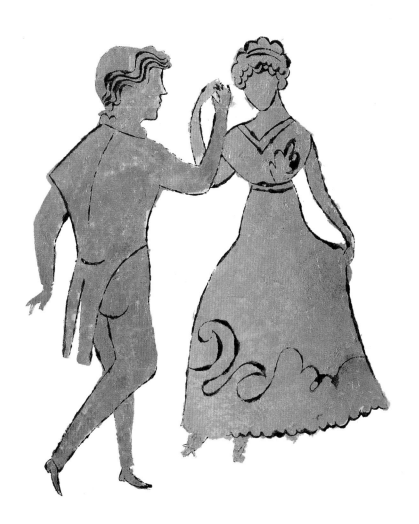

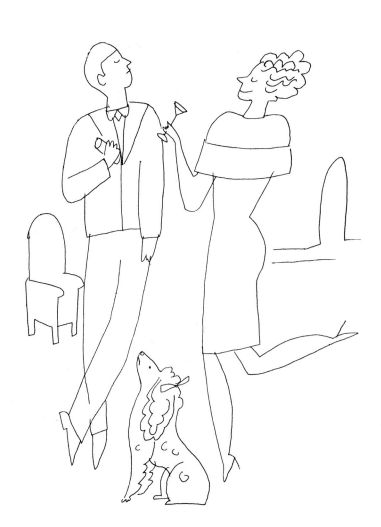

It's just like the comedies from the thirties

where the poor young guy arrives in Gotham,

showers,

shaves,

puts on a good suit,

and goes out into

Society to mingle

and nobody can tell

that he's not the heir

to some fortune.

Just dress to

mingle.

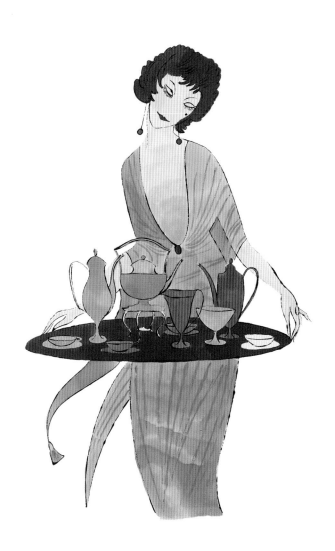

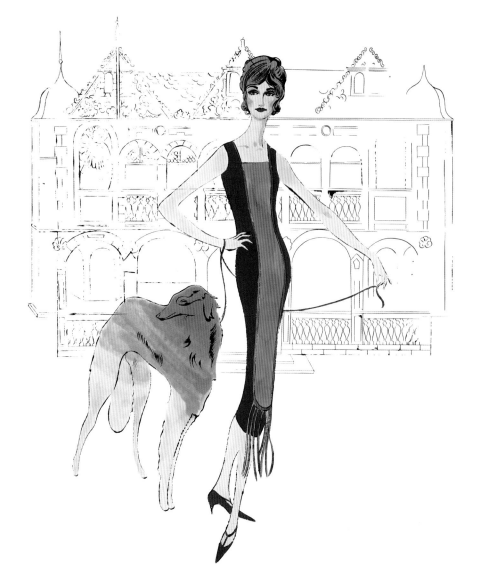

All you've got to do is look right and anybody will be happy to feed you, no questions asked.

She had a way with accessories,

too.

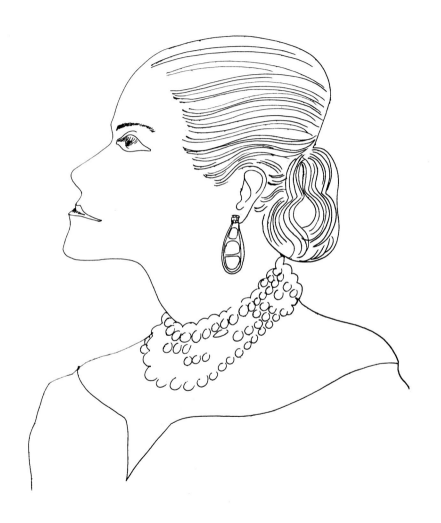

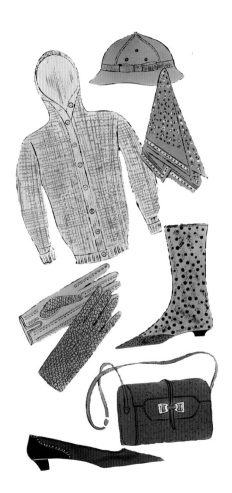

Everything

in your closet

should have an expiration date on it

the way milk and

bread and

magazines and

newspapers do.

They're simple,

and that's what American clothes *should* be.

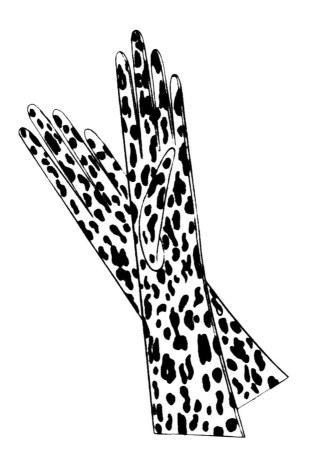

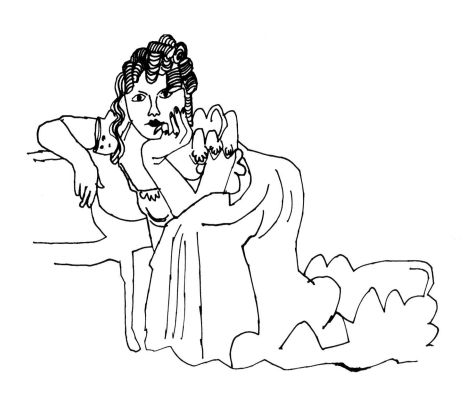

It's better to always wear
the same thing

and know that people

are liking you

for the real you

and not the you

your clothes make.

Think rich.

Look

poor.

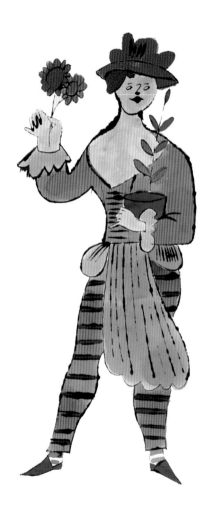

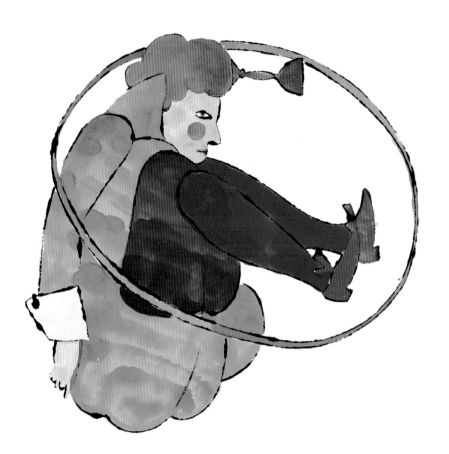

It's the **movies** that have really been running things in America....

They show you **what** to do, **how** to do it, **when** to do it, **how** to feel about it, and **how to** *look* how you feel about it.

He's afraid
he's just going to be a

flash

in the pan.

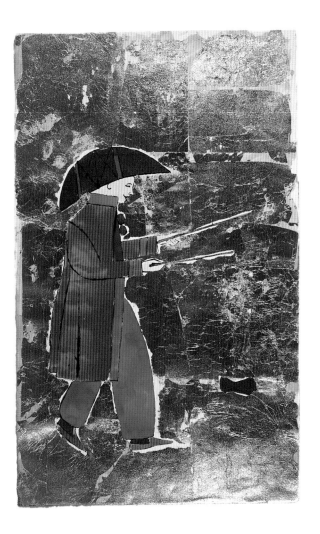

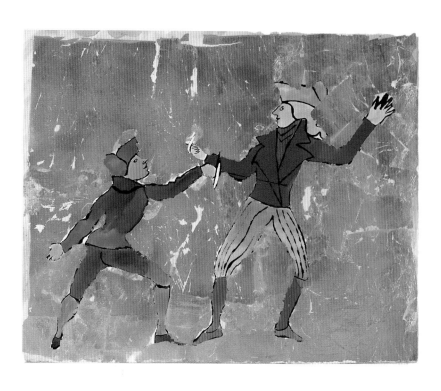

I was trying to think the other day
about what you do now in America
if you want to be successful.

Before,
you were dependable
and wore a good suit.

today Looking around, I guess that
you have to do all the same things
but not wear a good suit.

But they know how to buy cheap clothes that look great.

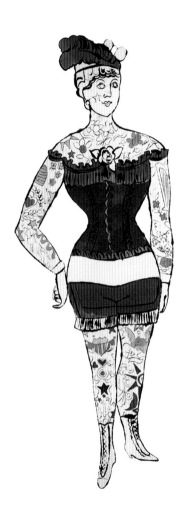

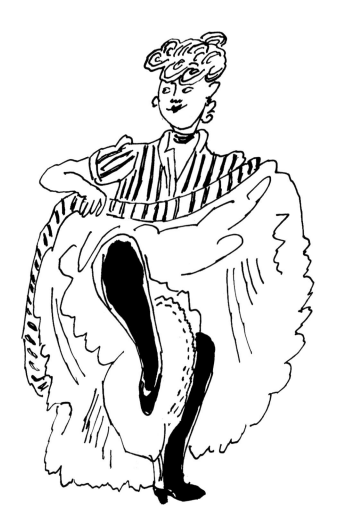

People would just

pop in and

buy new

disco

clothes

on their way in

to dance.

If you can convince
yourself that

you look fabulous,

you can save yourself

the trouble of primping.

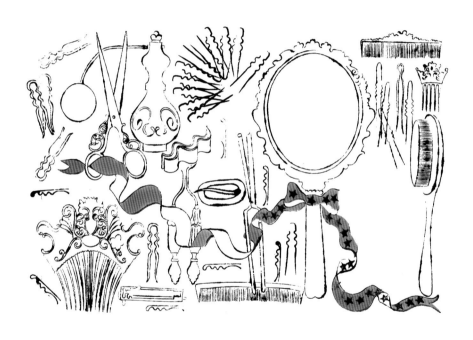

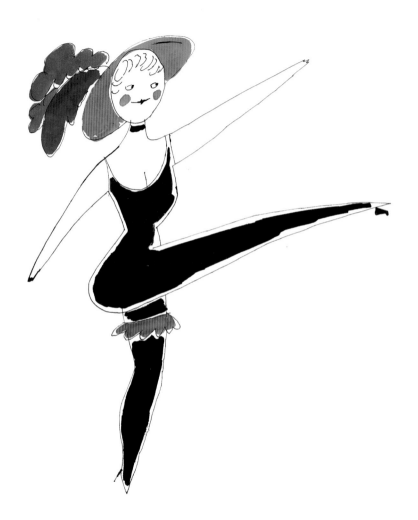

Of course, if you skip primping,
you lose the side benefits....

Grooming yourself
puts you in the

party
mood.

She
really
has
class
because
she'll
go
anywhere.

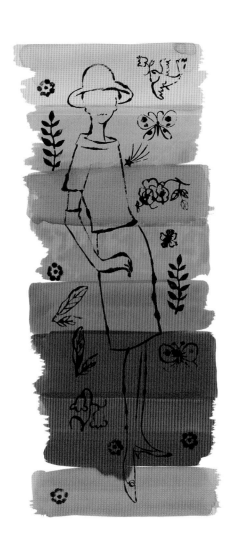

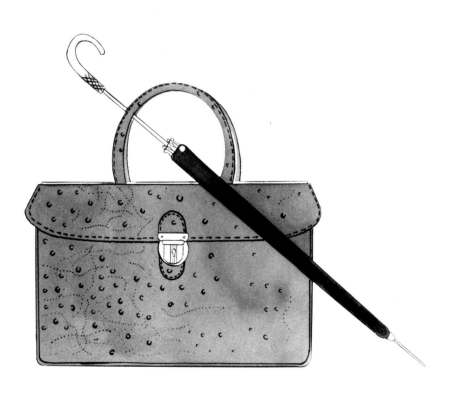

All quotations are by Andy Warhol
and were first published as follows:

Pages 11, 15, 19, 24, 35, 36, 44, 47, 51, 52, 59:
Andy Warhol. *The Philosophy of Andy Warhol (from A to B and Back Again)*. New York: Harcourt Brace Jovanovich, 1975.

Pages 7, 20, 31, 39, 40, 43, 55, 60:
Andy Warhol. *America*. New York: Harper & Row, 1985.

Pages 28, 64, 67:
Andy Warhol and Pat Hackett. *Andy Warhol's Party Book*. New York: Crown Publishers, 1988.

Pages 8, 16, 23, 63:
Andy Warhol and Pat Hackett. *POPism: The Warhol 6os.* New York: Harcourt Brace Jovanovich, 1980.

Pages 27, 32, 48, 56, 68:
Pat Hackett, Editor. *The Andy Warhol Diaries.* New York: Warner Books, 1989.

Page 12:
Mike Wren. *Andy Warhol in His Own Words.* London: Omnibus Press, 1991.

Captions by page number

Cover
 Untitled (Purse and Glove),
 c. 1956
 Ink and tempera on paper
 14 1/2" x 11 1/2"

Endpapers
 *Untitled (Multiple Fashion
 Accessories)*, c. 1958
 Ink on paper
 16 1/4" x 23"

3 *Untitled (Male Costumed Figure)*,
 c. 1956
 Ink and ink wash on paper
 22 1/2" x 14 1/2"

5 *Untitled (Couple)*, c. 1957
 Gold leaf, ink, ink wash, and
 stamped gold on paper
 22" x 13 1/2"

6 *Untitled (Five Male Costumed
 Figures)*, 1958
 Ink and ink wash on paper
 28 1/2" x 22 1/2"

9 *Untitled (Seated Female with Fan
 and Umbrella)*, c. 1956
 Ink and ink wash on paper
 23" x 14 5/8"

10 *Untitled (Two Men Fencing)*,
 c. 1957
 Gold leaf, ink, ink wash, and
 stamped gold on paper
 14 1/2" x 23"

13 *Untitled (Hats)*, c. 1958
 Ink and ink wash on paper
 17 1/4" x 23"

14 *Untitled (Male Costumed Figure)*,
 c. 1956
 Ink and ink wash on paper
 29" x 23"

17 *Untitled (Matador)*, c. 1956
 Ink on paper
 16 7/8" x 14"

18 *Untitled (Female Fashion Figure)*,
 c. 1959
 Ink and ink wash on paper
 21 7/8" x 16 1/2"

42 *Untitled (Female Fashion Figure)*,
c. 1959
Ink and ink wash on paper
28 7/8" x 22 7/8"

45 *Untitled (Helena Rubenstein)*,
c. 1957
Ink on paper
16 7/8" x 13 3/4"

46 *Untitled (Multiple Fashion
Accessories)*, c. 1960
Ink and tempera on paper
16 1/4" x 19 1/4"

49 *Untitled (Pair of Gloves)*, c. 1958
Ink on paper
13 3/4" x 11 1/8"

50 *Untitled (Female Figure)*, c. 1953
Ink on paper
8 1/4" x 10 7/8"

53 *Untitled (Male Costumed Figure)*,
c. 1955
Ink and ink wash on paper
22 7/8" x 14 1/2"

54 *Untitled (Male Costumed Full
Figure)*, c. 1956
Ink and ink wash on paper
19 5/8" x 25 1/8"

57 *Untitled (Walking Male)*, c. 1957
Silver leaf, ink, and ink wash
on paper
23" x 14 3/8"

58 *Untitled (Two Men Fencing)*,
c. 1957
Gold leaf, ink, ink wash, and
stamped gold on paper
14 1/2" x 23"

61 *Untitled (Female Costumed
Figure)*, c. 1955
Ink and ink wash on paper
28 5/8" x 22 5/8"

62 *Untitled (Female Figure)*, c. 1953
Ink on paper
11" x 8 1/2"

65 *Untitled (Toiletries)*, c. 1958
Ink and ink wash on paper
22 5/8" x 28 5/8"

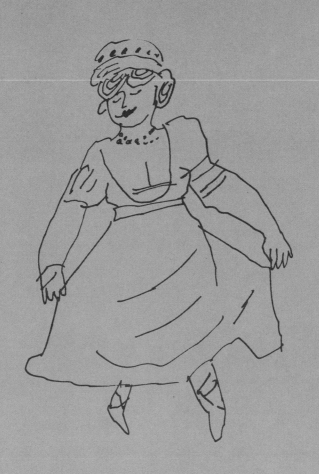